Hand Lettering through the Psalms

A CREATIVE DEVOTIONAL & INSPIRATIONAL JOURNAL

LEAH WEBER

Good Books

New York, New York

Good Books books may be purchased in bulk at special discounts for sales promotion, corporate gifts, fund-raising, or educational purposes. Special editions can also be created to specifications. For details, contact the Special Sales Department, Good Books, 307 West 36th Street, 11th Floor, New York, NY 10018 or info@skyhorsepublishing.com.

Good Books is an imprint of Skyhorse Publishing, Inc.®, a Delaware corporation.

Visit our website at www.goodbooks.com.

10 9 8 7 6 5 4 3

Library of Congress Cataloging-in-Publication Data is available on file.

Cover design by Leah Weber
Cover art by Candace Fincher

Print ISBN: 978-1-68099-643-2

Printed in China

TABLE OF CONTENTS

INTRODUCTION

This study is for the creative or non-creative, the perfectionist or the unorganized or the overwhelmed, busy woman. Really, it's for anyone who desires to develop a relationship with the Lord and create something beautiful in the process.

Why creativity in a devotional? I came up with the idea of having a creative aspect to a devotional study when I became a mom. I had very little quiet time throughout the day and I constantly felt conflicted about what to do with that spare time. Do I clean, create, read, pray, cook, talk to a friend, work on my blog, sleep? Through trial and error, and a few months of not getting in the Word consistently, I knew something had to change.

Creativity refuels me. And while yes, I am a naturally creative person, I also believe that every single one of us is made to create. God created us, this earth, and everything beautiful and wonderful, and we are image-bearers of God. So if you're a person who thinks you don't have a creative bone in your body, I would challenge you to go read Genesis 1 and 2. Read about everything that God created and then think about how you bear the image of that creative God.

This study is meant to help you develop a deeper understanding of God's Word, give you some guidance on what you read, and to inspire you to create something simple and beautiful. It is also meant to give you tools to help you meditate and memorize Scripture. With each devotional, there is a verse that you can trace and hang on your fridge, mirror, or wherever you will see it the most during the day. Not only will this give you something beautiful to look at that *you* created but it will also help you hide God's Word in your heart.

HOW TO

*W*hat You Will Need: The Bible, writing utensils. Feel free to use colors! (Put your perfectionist tendencies away for now.)

The Format: 1. Read the Psalm through a couple of times, find out who wrote the Psalm, the context of the Psalm, and anything else that might help you understand that Psalm better. 2. Read the devotion that correlates with the Psalm. 3. Trace the verse and color in the designs if you so desire. 4. Tear out the verse and put it somewhere you can see it during the day to help you remember and memorize what you learned that day. 5. Practice more lettering as you respond to the journaling prompts in the lines provided.

Tips for Lettering: 1. The downstrokes on a letter are always a little thicker. 2. Micron® pens are my favorite and can be found at any craft store or on Amazon.com, but feel free to use any kind of pen and color that you like. 3. It doesn't have to be perfect. The goal of lettering the verse is to help you meditate, memorize, and create. *Not* to create something perfect. What I love about hand lettering is that everyone has their own unique style of lettering. Even my style has evolved over the course of creating this book. Don't feel like your lettering has to look exactly like mine. Once you've learned the basics, make it your own!

MEDITATION

MEDITATION

PSALM 1: MEDITATE ON THE LAW OF GOD

The first time I ever participated in a yoga class, I didn't know whether to start laughing or be weirded out when I was asked to empty my mind and focus on my breathing. I find it extremely difficult to empty my mind at all because 1. I am an internal processor, so my mind is constantly running and 2. I'm a mom. It's also not what God has in mind when he told us to meditate day and night.

God doesn't want us to empty our minds; instead, he wants us to fill our minds with His Word. This can be challenging in the midst of our busy lives. Whether you're a student in college, trying to balance work, homework, and friendships, or you're a mom who rarely has a spare minute to breathe, getting in the Word consistently can be challenging. Memorizing Scripture may seem like an impossibility!

Psalm 1 says that the person whose delight is in the law of the Lord is blessed. Spending time with God shouldn't be something that we feel obligated to do or something that we just check off our to-do list, it should be something that we "delight" in.

Think about your friendship with your best friend or spouse. If you were only ever to communicate with them once a week, once a month, or on holidays, what do you think your relationship would be like? Either poor or nonexistent. This is how we need to view our relationship with Jesus. It's an actual relationship. While God isn't in front of us in the flesh, we can communicate with Him through prayer and get to know Him on a more personal level through the Bible.

So often we view God as a demanding king and forget that He is a loving, merciful, gracious Father. Jesus tells us to approach Him as a child approaches his father: humble, expectant, and with childlike faith.

Practice

on his law
he MEDITATES
day & night

PSALM 1:2

What do you meditate on other than Jesus? In your heart of hearts, how do you think God views you?

MEDITATION

PSALM 56: MEDITATE ON THE WORD OF GOD

Meditation means to "engage in contemplation or reflection." So often we correlate meditation with the practice of yoga and "emptying our minds." But in reality, meditation is about *actively* contemplating or reflecting on something. In the biblical context, we want to actively meditate on the Word of God.

In Psalm 56, some form of the phrase "in God I trust; I shall not be afraid" is repeated three times. This is obviously a phrase that is important and needs to be meditated on. As someone who is often fearful, I find that the phrase "do not be afraid" is something I need to repeat over and over again on a daily, hourly, sometimes minute to minute basis. When David wrote this, he was being attacked by literal enemies. Our "enemies" today are often more likely to be enemies of the mind, like hormonal imbalances that lead to depression and anxiety.

In a world that is constantly telling us that "We have what it takes" and that "We are enough," it's hard to sift through what is true and what is a lie. But if you've ever dealt with depression or anxiety, you know that you can't just "snap out of it." No, we need something far, far greater than our own strength to pull us out of fear. I often think of the verse, "Be strong and courageous. Do not be frightened, and do not be dismayed, for the Lord your God is with you wherever you go." (Joshua 1:9) This verse doesn't say, "be strong and courageous, because you are enough" or "be strong and courageous because you have what it takes." The *only* way we can be strong and courageous is because *the Lord* is the one who is going to fight for us. In fact, the Bible tells us that we aren't enough, we've failed on every level.

Practice

WHEN I AM

afraid

I PUT MY

trust

IN YOU.

PSALM 56:3

What are some specific things in your life that cause you to be afraid? Are you trusting the Lord in those areas?

MEDITATION

PSALM 77: THE FAITHFULNESS OF GOD

Fun fact: my name, Leah, means "weary one." I don't think my parents realized that when they named me. (They did know, however, that the Leah in the Bible is part of the lineage of Jesus.) For a lot of my life I've dealt with "weariness." I'm a nine on the Enneagram and I recently discovered that nines have the least amount of energy of all the numbers in the Enneagram. Go figure. Not only does my name mean "weary," but my personality type is also the least energized. It seems like I'm doomed to a life of perpetual exhaustion.

I'm sharing all of this because in Psalm 77, the psalmist describes something similar to exhaustion. He is crying out to the Lord and can barely keep his eyelids open. He isn't just describing a physical exhaustion; he's describing an emotional, spiritual, and physical exhaustion that he can't conquer. He even begins to question the love, grace, and compassion of God. We have all found ourselves here at some point in our lives. During seasons of infertility, death of a loved one, unanswered prayers, we question the goodness of God.

The psalmist gives us a guide for what to do in those dark places when we're questioning whether or not God loves us. He meditates on what God has done for him in the past. It's so easy for us (especially me) to get stuck in present hardship, wondering when it will end. But instead of looking to "self-care" tips or our next vacation to numb the hardship we are going through, we need to dwell on the goodness of God and His grace to us in our lives.

The psalmist uses the word "selah" three times in this passage. Selah is used as a break in the Psalm. In a culture where we don't want to stop and wait for anything, it can be difficult to pause mid-psalm and think about what the psalmist is saying. But meditation, pausing, and thinking about the Word of God and what He has done in our lives is how we are going to grow in the knowledge of God and in the understanding of the Bible.

Practice

I will remember the Deeds of the Lord

PSALM 77:11

When you become physically and emotionally exhausted, who or what do you turn to?

MEDITATION

PSALM 103: WHO GOD IS

So often when we pray to the Lord we come to him with a list of requests. While this isn't bad in and of itself, we are also called to "bless the Lord." Fortunately, Psalm 103 helps us by showing us all the ways we can bless and adore our Lord.

Dwell for a bit on who God is, as described in this Psalm. He forgives. He heals. He redeems life from the pit. He satisfies us with good. He is merciful and gracious. He is abounding in steadfast love. He does *not* deal with us according to our iniquities. He is compassionate.

Through reading and meditating on this Psalm, the phrase that stuck out to me the most was He "redeems your life from the pit." One thing I've learned in the past ten years of walking alongside all sorts of different people is that anxiety and depression do not distinguish between social classes, ethnicities, material items, or how good your life may look on the outside. Through my first years of marriage and after my first child, I dealt with panic attacks. Anxiety is closely linked to depression, which I also experienced postpartum after my first child. I look back on this time as an extremely low point in my life. I don't remember much about the first year of my daughter's life, but I do remember feeling like I was in a black hole. While I wouldn't choose to go back there again, I will say that the Lord has been extremely gracious to me, and this devotional is a direct outcome of that dark season of my life.

If you feel like you are currently in a "pit," you may be wondering, "When will God redeem me out of this pit?" While I don't know when or how or why, I do know that the Lord is "abounding in steadfast love." While you may never know the "why" in this life, you can rest in the fact that the Lord is good, that He loves you, and that He *will* redeem your circumstances, whether in this life or the next.

Practice

Bless the Lord O my Soul

PSALM 103:2

Who is God in this passage? What are some examples of ways that God has redeemed you out of the pit?

MEDITATION

PSALM 119: 9–16: HIDING GOD'S WORD IN OUR HEARTS

In a Bible study I'm leading with some college women, a question came up about what the word "hidden" means in Psalm 119. If we are supposed to share God's Word with others, then why does it tell us to keep God's Word "hidden in our hearts"? We looked up different translations of that verse and discovered that another word used for hidden is "stored." We also looked at the context of the verse. My friend who co-leads the study made a good analogy. She said that often when we highly value something, we "store" it or "hide" it somewhere in our house, such as in a safe. When we hide, or store, God's Word in our hearts, it is because we value it. In order to keep God's commandments, we need to know his law.

Whenever my husband talks about meditating on the Bible, he gives the analogy of a cow chewing its cud. It's kind of a gross illustration, but when a cow eats grass, it chews on it, swallows it, then spits it back up, chews it some more, and swallows it again. This is how we meditate on Scripture. We read it, think about it, memorize it, and think about it some more. If we never read or memorize Scripture, then when temptation comes our way, we won't be able to combat the lies that the enemy is telling us.

Scripture memorization is hard for me, especially now that I have children—my mind is constantly whirring with other things I need to remember. By writing Scripture out and hand lettering it, it gives me time to think about the verse as well as memorize it. I hope the process of hand lettering a verse helps you memorize and meditate on Scripture, too!

l l l

E E E

I HAVE STORED UP your word in my HEART THAT I MIGHT NOT SIN AGAINST you

PSALM 119:11

What is something you highly value? Do you value Scripture as much?

REPENTANCE

REPENTANCE

PSALM 6: REPENTANCE IS HARD

Repentance is hard for me. Frankly, I'm bad at it. I'm defensive and prideful when I'm confronted with my sin, and I constantly make excuses in my head of why I'm not in the wrong. But nothing shows my sin so clearly to me as motherhood. I find myself easily being impatient and frustrated with my children. In a world that tells us we are "enough," David clearly states that he isn't enough. He can't pull himself out of the mess he is in. He is troubled, weary, grieved, and weeping. How often do we find ourselves in the same state as David? We are anxious, exhausted, fighting back tears. If you've ever experienced any of these emotions, you know how challenging, or even impossible, it is to believe that you have what it takes to pull yourself out of that emotional state. How much more is it impossible for us to fix our sin issues on our own?

The Lord Has Heard my Plea

PSALM 6:9

Is it hard for you to repent? Why or why not?

REPENTANCE

PSALM 32: FORGIVING OTHERS

Have you ever been in a position where you've been in a fight with someone or you sense tension between you and another person and you don't do anything about it? What happens? For me, it feels like a weight is on my heart or there's a sadness or bitterness that I just can't shake. David describes what he feels like when he doesn't repent. He says, "My bones wasted away through my groaning all day long. For day and night your hand was heavy upon me; my strength was dried up as by the heat of summer." His description sounds a little dramatic, doesn't it? Yet he is putting to words what we so often feel when we are unrepentant. There is a literal physical reaction when we don't repent or when we hold back forgiveness from someone.

Admitting we're wrong is hard. Our pride gets in the way and we want to blame shift all of our issues onto someone else. But the good news of the gospel is that when we do repent, God forgives us. It sounds so simple, and yet why is it so hard? My husband has pointed out to me numerous times that I always seem hesitant to be forthcoming about my sin. And it's true. Whenever we have a conflict and my husband apologizes to me, there is something in me that holds me back from apologizing to him. In my sin and pride, I want to be right and I want to be justified in my anger. But inevitably if I withhold my forgiveness, I don't sleep well, I feel exhausted, and I have a constant nagging feeling. However, once I confess my sin to my husband and God, I feel like a weight is lifted off of me.

My prayer for myself and for you is that we would run to Jesus when we sin. And that we would view God as a loving father who desires to forgive us and to welcome us into his arms.

You are a hiding place for me

PSALM 32:7

Do you find it hard to forgive others? How does this passage change your view of why we should forgive?

REPENTANCE

PSALM 38: THE CONSEQUENCES OF OUR SIN

A topic that I rarely hear talked about in Christian circles is the consequences of our sin. We emphasize God's love for us and one another but we overlook the fact that He is also a righteous judge. In Psalm 38, David is deeply afflicted. He is crying out to God to relieve his affliction but he also owns up to his sin. He says "There is no health in my body . . . because of my sin." While we are perfectly righteous before God because of Jesus, we will still have consequences to our sin in this life because, well, we still sin.

It can be uncomfortable to talk about consequences to our sin—in fact, these devotions on repentance have been by far the hardest for me to write. I don't like talking about uncomfortable topics or things that will make other people feel uncomfortable. But it is only through confronting our sin head on that we will learn how to repent, receive God's grace, and grow closer to God.

I don't know about you, but it's easy for me to think I need to "clean myself up" before I come to God in prayer. But that's the exact opposite of what the gospel says. We need to come to the Lord in our need—that is where He meets us and forgives us. While David is in deep anguish in this Psalm, he gives us hope in verse 22 when he says, "Make haste to help me, O Lord, my salvation!" John Calvin puts it this way: "That whatever might happen, he was, nevertheless, well assured of his salvation in God." In David's cry to the Lord to quickly help him, he is also resigning himself to the fact that no matter what happens, he knows he is saved by God.

h h h

H H H

i confess my iniquity i am sorry for my sin.

PSALM 38:18

Are you confident in your salvation? Why or why not?

REPENTANCE

PSALM 51: HOW TO REPENT WELL

Have you ever thought about what causes you to sin? Not the external circumstances but the deep down root of the issue. What deep desires of your heart are causing you to sin? I'll give an example from my life. A deep desire of mine is to have inward and outward peace. While that is a good and right desire, it is also a desire that is distorted by sin and can become an idol in my life. This shows itself in multiple ways. When my children are being overly loud or throwing tantrums, I tend to shut down, withdraw, or lash out in anger. Because my peace is being disrupted. Or when my husband brings up something controversial, I withdraw or make excuses because I don't want my peace to be disrupted (I also hate conflict with every fiber of my being).

Oftentimes, what causes us to sin is simply desiring the things of this world over God. In verse 12 David says, "Restore to me the joy of your salvation. . . ." This implies that David was not seeking the joy of the Lord when he sinned. It also implies that if we are seeking joy in the Lord, we are going to be less likely to seek joy from this world and therefore less likely to sin. Where are you seeking your joy?

When I think about the idols in my life, specifically the desire to always have peace, I am sometimes discouraged by how deep the root of that idol goes. Almost everything I do in my life goes back to whether or not it will disrupt my peace. I'm not actively seeking peace from God, I'm seeking it in my own strength, trying to control my circumstances. I want to encourage you to take some time and think about what your deep desires are and how they may have become distorted by sin and are now idols in your life.

Practice

i i i

I I I

Create
IN ME A
Clean
HEART
O God
PSALM 51:10

What are some of your deep desires? How have they been distorted by sin?

REPENTANCE

PSALM 133: DWELLING IN UNITY

This Psalm is a short but beautiful depiction of what it looks like to "dwell in unity." David describes the unity of brothers like the "dew of Hermon, which falls on the mountains of Zion." (verse 3) This dew is like a mist that comes during the hottest season of the summer in Israel. The mist first descends on Mount Hermon and then from there flows into the valley. The mist allows everything to be renewed and grow in the valley. Isn't this a beautiful illustration of what unity looks like? When Christians forgive each other and unite for one cause in Christ, it is like a refreshing mist that allows everything to grow in its path.

Forgiveness can be a hard concept to put into action in a culture that is polarized on so many issues. Forgiveness can also be messy and complicated when the offending person doesn't offer an apology. How do we forgive someone who has hurt us when they don't show signs of any remorse? Romans 12:18 says, "If possible, so far as it depends on you, live peaceably with all." We are called by Jesus, no matter how difficult, to live at peace with each other as much as we can. Meaning, we may have to approach someone who is intimidating. Or we may have to forgive someone who has never apologized to us. I realize that this is easier said then done and it is something to pray long and hard about.

Just thinking about conflict makes me want to literally throw up. But while I hate it, I've also seen how restorative and necessary it is to experience conflict and resolve it. The illustration of Mount Hermon is perfect because it truly depicts what happens when one person approaches someone in unity. There is a life-giving mist that flows through that relationship and allows growth and healing.

Practice

j j j

J J J

Behold how Good & Pleasant it is When brothers Dwell IN Unity

PSALM 133:1

How can you "dwell in unity" without faking peace? Have you ever had to forgive someone who didn't apologize to you?

PETITIONING

PETITIONING

PSALM 4: HOW TO WAIT WELL

There have been times in my life, as I'm sure there have been in yours, when I've prayed to God about something and felt like He wasn't listening. Maybe you feel like that today. Waiting is hard, especially in a culture that values and desires getting everything in an instant. If you are in a season of waiting, I would encourage you to be like David in verse 1 and recall the times in the past when God has given you relief in the midst of distress.

We so often forget how the Lord has been faithful to us in the past. In Exodus we see how the Israelites are constantly forgetting God's deliverance from Pharoah. While it's easy to judge the Israelites and think that they are foolish to forget so easily, we have to ask ourselves, how often do *we* forget God's faithfulness?

I've noticed that oftentimes when we forget God's faithfulness and goodness towards us, we develop anxious and joyless lives. Thankfulness can often be the antidote to anxiety. If we remember God's past faithfulness to us and are thankful, we are less likely to be anxious in the present moment, even if what we are facing is scary. In the midst of imminent danger with Saul and his army, David is able to say, "In peace I will both lie down and sleep; for you alone, O Lord, make me dwell in safety" (Psalm 4:8). David isn't relying on the peace of his circumstances but rather the true peace that only the Lord can provide.

k k k

K K K

FOR YOU ALONE

O Lord

MAKE ME

dwell

IN safety.

PSALM 4:8

What are some examples of ways that the Lord has been faithful in your life? Take some time to thank Him for His faithfulness.

PETITIONING

PSALM 5: DWELL IN HOPE

As I've been working through these 25 Psalms, I've noticed a repetition of the word "dwell." Dwell is a verb that means to "live in or at a specified place." In this Psalm, David is saying that evil cannot "dwell" with God. Psalm 16:9 says to "dwell in hope." Psalm 4:8 says that "You alone O Lord, make me dwell in safety." In a society that is riddled with anxiety, what does it look like for us to "live" in hope and safety? This safety isn't found in the comfort of our own homes and we can't put our hope in anything that this world has to offer. So how can we tangibly live in God's safety and hope?

As someone who has dealt with different seasons of anxiety, the idea of dwelling in hope and safety is the opposite of what I often feel. When I first became a mother to a rambunctious, colicky, hard-to-please baby girl, I very often felt like I had no hope, that my life, free time, and peace were all taken away from me. But that was because I was seeking my hope and joy in the circumstances of my life. I was looking for peace in my home where there was now a crying baby. I was seeking hope in having children, which was nothing like I had imagined. And I was desiring safety in my circumstances that seemed to be constantly changing.

What I didn't realize back then was that the Lord was teaching me that I couldn't expect hope, safety, joy, or peace to come from anything on this earth. While I have a feeling that this will be a lifelong learning process for me, I'm also thankful that I realized this early on in motherhood. I want to challenge you to think about what you are "dwelling" in. Is it your career, your children, your spouse? None of these things can bear the weight of our hope. Only Jesus can.

Practice

\mathcal{L} \mathcal{L} \mathcal{L}

\mathcal{J} \mathcal{J} \mathcal{J}

but let all
who take
Refuge
in you
Rejoice.

PSALM 5:11

Where do you place your hope? How can you actively dwell in hope today?

PETITIONING

PSALM 75: VENGEANCE IS THE LORD'S

In a society that is currently polarized on, well, everything, it's easy to forget who is ultimately in control. Verse 3 says, "When the earth totters, and all its inhabitants, it is I who keep steady its pillars." Even though the Bible was written two thousand years ago, the phrase "the earth totters" feels exactly like what is going on right now. A.W. Tozer said, "How completely satisfying to turn from our limitations to a God who has none."[1] This is ultimately what prayer is. We are taking our limitations, our "not enoughness," and giving them to a God who is all powerful and in control of everything.

When I begin to look at and consider all of the evil that is in the world, it is easy for me to become anxious. When I think about the problems of foster care, sex trafficking, and abortion in the US alone, the obstacles of trying to make any sort of change feel simply insurmountable. I've been slowly learning the balance between discovering the ways that I can help, even in some small way, with these issues, while also ultimately taking these issues to the Lord.

Elisabeth Elliot said that "fear arises when we imagine that everything depends on us." This is often why we become afraid of the future, afraid of who is going to be elected to the office of president, afraid of decisions made by the Supreme Court. We believe that the trajectory of our lives solely depends on us and what we decide. And while we do have a responsibility to take action on these matters, we must not forget that the outcome of our lives, and of every single person on earth, is ultimately in the hands of God.

1 A.W. Tozer, *The Knowledge of the Holy* (San Francisco: HarperOne, 2009)

m m m

M M M

WE
give thanks
TO YOU
O God

PSALM 75:1

Do you struggle with feeling the need to control everything in your life? Do you truly believe that God is in control, even in the midst of chaos?

PETITIONING

PSALM 83: TURNING OUR ENEMIES OVER TO GOD

There's a moment in college that I vividly remember. I had just broken up with a (not so great for multiple reasons) boyfriend and I was angry, sad, and feeling a little revengeful. My roommate and dear friend said to me, "Leah, you have to remember that the Lord will fight for you; you only need to be still." Since then, I've heard this verse quoted often, but when my friend told it to me, it was the first time I'd ever heard it. The context of this verse in Exodus 14 is that the Israelites have fled Egypt, but God has hardened the heart of Pharaoh, who is following after the Israelites to kill them. When the Israelites see that Pharoah is after them, they are terrified and question why God brought them out of Egypt only to have them killed by Pharaoh's army. Moses says to the Israelites, "Fear not, stand firm, and see the salvation of the Lord, which he will work for you today. For the Egyptians whom you see today, you shall never see again. The Lord will fight for you, and you have only to be silent." (verses 13–14)

In Psalm 83, David is calling out and asking God to strike down his enemies. This seems rather harsh, and you may be asking how David can ask these things when we are called to love and forgive our enemies. But David is not seeking revenge on his own. He is asking God to act justly with these enemies and to do whatever He wills is right. Just as God protected the Israelites from Pharaoh's army, He fights for us against the armies that seek to destroy us.

n n n

N N N

O God

DO NOT KEEP

silence

DO NOT HOLD YOUR

peace

OR BE

still

O GOD!

PSALM 83:1

Who is God in this passage? Are you prone to want revenge or are you able to let God fight for you?

PETITIONING

PSALM 108: ASKING GOD FOR COURAGE

In our world of social media, we are bombarded with phrases like "You can do it," "You're brave enough, smart enough, strong enough," etc. But the reality is that we are none of these things without God. These phrases don't motivate me because I daily see how I fail at every one of these sentiments. I'm not patient enough with my little girl. I'm not strong enough to handle the fear and anxiety that often overtakes my mind. I'm not brave enough to walk up to a stranger and share the gospel with them. I am utterly inadequate. The only way I can be equipped to handle hard situations is by knowing that I am a child of God and That I love Him more than I love myself.

Courage is not the absence of fear. It's finding something that is worth more to you than your fear. Where do you find courage like that? David faces his fears because his love for the Lord overcomes any fear that he has.

I often wonder how some people can go overseas to dangerous places as missionaries. Some people may simply not be afraid, but a lot of people can do that sort of thing because they've found something that is more important to them than their fear. Their love for people and ultimately their love for Jesus is more important to them than the fear of disease and uncomfortable living situations.

As Christians, we should be the most courageous people on earth because we know that we can trust God in all of our circumstances.

WITH God WE SHALL DO Valiantly

PSALM 108:13

What are some areas in your life where you lack courage?

SORROWING

SORROWING

PSALM 39: BEING HONEST WITH GOD

You may be wondering why I chose to put Psalm 39 in this book. It's not very encouraging. In fact, it doesn't seem to have much hope in it at all. Still, there is an important lesson we can learn from this, even though it may not be the most uplifting Psalm.

In many of the Psalms, David is crying out to God. And most of the Psalms have a "But God" paragraph where David ends by declaring that despite his dire situation, God is in control. Psalm 39 doesn't end like this. So often when we are in a season of waiting or extremely difficult circumstances, it's hard and sometimes impossible to get to the "But God" in our prayers. We can honestly cry out to God in our situation, but since we can't see the end of our trial, we can lose hope in our situation.

The good news is that in the hard circumstances, we don't have to conjure up some sort of superficial happiness. Unlike the popular saying, God actually *does* give us more than we can handle. When we are drowning in our hopeless circumstances, God wants us to draw near to Him for comfort, to rely on Him and not on our own abilities. He also doesn't want us to fake optimism. He wants us to be honest with Him, but also to trust that He is in control of our circumstances.

When we can't get to the "But God" in our lives, the only thing we can do is pray that the Lord would draw near to us in our waiting.

Practice

𝒟 𝒟 𝒟 𝒟

𝒫 𝒫 𝒫 𝒫

My
HOPE
IS
IN YOU

PSALM 39:7

Are you honest with God during your trials? Are you putting your hope in this life or the next?

SORROWING

PSALM 9: PRAISING GOD IN DIFFICULT CIRCUMSTANCES

Praising God can feel difficult. Our hearts are heavy and weary from work, school, ministry, tough relationships, mothering, or some combination of these things. These times of weariness can feel like they will last forever. I often get stuck in this rut when big changes happen in my life. Getting married, moving houses, having a baby—they have each felt like changes that I would never be able to adjust to.

A wise woman told me that most of our lives consist of waiting. Waiting to get married, waiting to become pregnant, waiting for a good job, waiting, waiting, waiting . . . and if not done correctly, waiting can lead us into paths of discouragement and discontentment.

So what are we to do in times like this? David says that part of what thanksgiving is, is reflecting on what God has done for us in the past. It's almost impossible to see the good outcome or the end of something when we're in the middle of suffering. But what we can do is look back on our lives and remember when God has been faithful to us. When was a time that you felt closest to God through a difficult circumstance? These are times to reflect on the faithfulness of God in your life and to give Him thanks in those circumstances.

Waiting is not only remembering how God has been faithful to us in the past, but it is also actively seeking Him and asking Him to show up in our present. Some of the ways we can avoid becoming bitter during waiting periods is by repenting of our unbelief, and being active in reading the Bible and in prayer.

q q q

Q Q Q

for you oh Lord have not forsaken those who seek you

PSALM 9:10

What are some examples of seasons when you've had to wait? What are some practical ways that you can "wait well"?

SORROWING

PSALM 34: GOD'S PROMISES IN SUFFERING

Life brings suffering with it. In our modern society, we've lost the concept that this life inevitably brings suffering. We think that we are in control and if we just do everything right, we will be safe from hard things. Being a woman can bring unique sufferings with it as well. Competing for equal pay in the workplace, suffering with infertility and miscarriages, balancing home and work life, struggling with singleness and loneliness, these are all extremely difficult circumstances that can make us question our relationship with God. On particularly hard mothering days I've asked Jesus how He can understand and relate to my life when He was never a woman or a mother.

The counterintuitive fact of suffering is that it's actually in our trials and difficult circumstances that we have the opportunity to be closest to God. Psalm 34 says that "The Lord is close to the brokenhearted, he saves those who are crushed in spirit." While it can be natural to feel the urge to pull away from God and question His goodness in suffering, it's actually where He so closely meets us.

We have to remember that our sufferings in an evil world are not created by God. It is because of our sin and fallen nature that we struggle. But we do have hope that God is sovereign and He is therefore at work in our sufferings and uses them for good.

Becoming a mom was hard for me. It didn't feel natural, I mourned deeply the loss of my freedom and time. I fell deeply into a pit of anxiety and sometimes depression. But it is also where the Lord showed me clearly who I am, the good and bad, my passions, and what I believe to be His calling on my life. If you are in a time of suffering, ask God to draw close to you and to teach you more about Himself.

Practice

the Lord
is near to the
brokenhearted
& saves the
crushed
in spirit.

PSALM 34:18

Who is God in this passage? How do you handle suffering?

SORROWING

PSALM 41: TAMING THE TONGUE

We often think about gossip as telling lies about someone to someone else. But really, gossip is often telling a truth about someone that should be left unsaid. David is dealing with the issue of gossip with some of his closest friends.

There are not many more hurtful things that you can experience than hearing that your close friend is telling your secrets behind your back. For women, this can be one of the easiest ways that we lose trust in each other. And when we lose trust in each other, we lose friendships and community. David says in verse 9 that even his best friend has been unjust to him. It is one thing for a stranger to accuse you or gossip about you, but a close friend is much different. It is easy to respond in anger or become bitter when something like this happens to you. But David responds by reminding himself that God is gracious to him and delights in him. This is enough for David and should be enough for us.

In a world where we often live far from our biological families, friendships are even more important because these are often the people we rely on in difficult situations. Avoiding gossip can be difficult, but even more difficult may be forgiving someone who has gossiped against us. We often become bitter and carry grudges against one another. The only way we can experience and give forgiveness is by reflecting on the ultimate sacrifice that Jesus gave to us and extending that to one another.

Gossip not only hurts our friendships but it also harms our villages and our families. If this is something you struggle with, ask God to forgive you. If you've been hurt by someone who has gossiped about you, tell that person how they have hurt you and seek restoration.

Practice

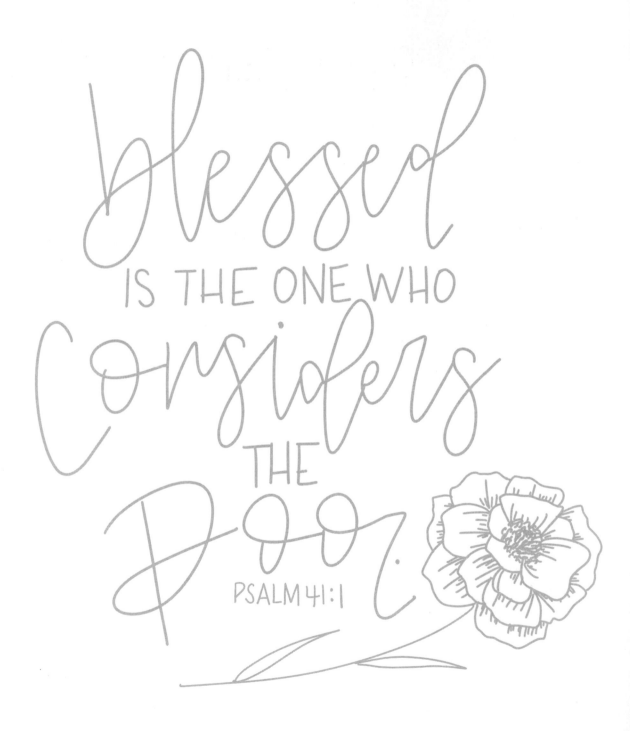

Blessed
IS THE ONE WHO
Considers
THE
Poor.
PSALM 41:1

Do you struggle with gossip? What do other passages in the Bible say about gossip?

SORROWING

PSALM 88: WAITING IN HARDSHIP

Psalm 88 doesn't end on a high note. Most of the Psalms end in some form of "But God," language where the writer praises God for His faithfulness amidst his trial. But this Psalm doesn't end like that. It ends by saying, "You have caused my beloved and my friend to shun me; my companions have become darkness." At first glance this seems to be a rather hopeless Psalm. But with further investigation and meditation, this has become one of the most encouraging Psalms for me.

Quite often when trials come our way, they appear to come in multiples. A family member gets sick, then someone loses their job, a relationship becomes difficult, and so on and so forth. In the midst of these seasons of darkness, it is easy for me to become depressed and beaten down by the weight of continuous trials. Some of the hardest trials I've seen are when there is a "chronic" problem, like a challenging child, or a chronic illness. It is hard to find hope in these situations when they appear to be never-ending. As Christians, we can sometimes feel the pressure to always find the light at the end of the tunnel, or always offer some sort of hope to a friend in a tough spot. But this Psalm shows that there are some circumstances and seasons of life that are really hard and the only thing we can do is cry out to God.

Elisabeth Elliott puts it perfectly when she is describing the answer to our "why?" questions. Shes says, "The answer I say to you is not an explanation but a person, Jesus Christ, my Lord and my God." (Elliott, 19, p.12) We may never know the specific reasons why we are suffering, but we can put our trust in the person and work of Jesus Christ.

Practice

T T T T

T T T T

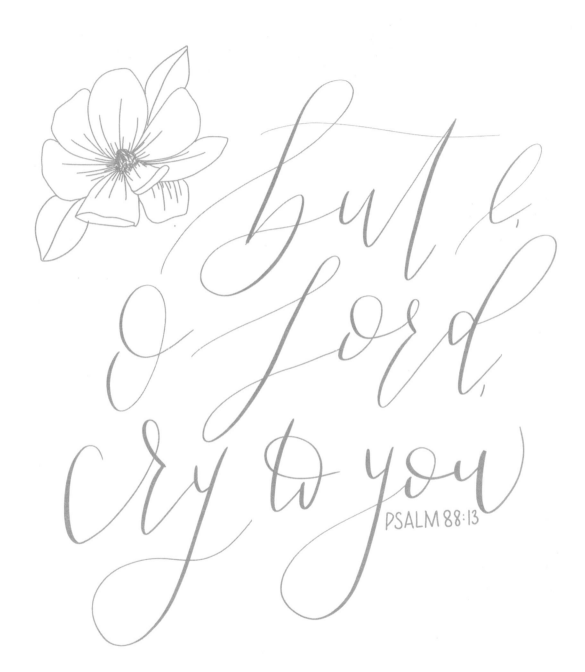

but I,
O Lord,
cry to you

PSALM 88:13

During seasons of suffering, do you turn to God in prayer, or are you prone to despair?

SORROWING

PSALM 16: FIGHTING IDOLS IN OUR LIVES

Have you ever considered that you may have idols in your life? The most difficult thing about idols is that they are often good things that have become too important in our lives. A significant other, our children, our dreams, all our good and beautiful things. But when they become more important than God, we inevitably become disappointed, discouraged, and depressed when life takes these things away from us. The only way we can escape the tight hold our idols have on us is by desiring God more than anything else.

As each year passes I see more and more how suffering is often intermingled with goodness. We can go through seasons where everything in our family's life is going well, but the burdens that our friends and community are going through are hard to bear.

It is easy to fall into despair when we realize the extent of suffering in this world and know that there won't be many seasons where we won't be touched by heartache. The only way to combat despair is by pursuing God and knowing that we are living in a temporary home. Soon, every tear will be wiped from our eyes and we will live eternally with God in a perfect body.

What we also must see is that our greatest blessings are oftentimes the things that are hardest in our life. For example, having children is the hardest thing that I have ever done. When I say that to people, they often ask me, "but aren't they also your greatest blessings?" I say yes, but not in the way you think. We typically think of blessings as good and happy things, when in reality blessings are often the things that make us grow the most. My children are a great blessing because they are my undoing. I can no longer rely on myself; I must turn to Jesus for help. That is why they are a blessing.

Practice

4 4 4

ν ν ν

therefore

MY HEART IS GLAD

&

my whole being

REJOICES;

my flesh also

DWELLS

secure.

PSALM 16:9

What are some idols in your life? How are you actively fighting these idols?

ADORATION

ADORATION

PSALM 27: DISCOVERING OUR HEART'S TREASURE

Fear shows us what our hearts most desire. What are you afraid of losing? For me, it's often the simple things like comfort, sleep, and freedom. I know these three things to be idols in my life because they are what I missed the most when I had a baby. It's also what I continue to fear to lose even more of if we have more children.

Often as women, most of our fears can be summed up in two words: "losing control." Unfortunately, any control that we think we have in this world is mainly an illusion. To fear losing control is to be in a constant state of fear.

How does David combat his fears? He focuses on his communion with God. He seeks God's face, he gazes upon the beauty of the Lord, and he sings to the Lord.

Our greatest treasure must be our relationship with God. As someone who has suffered from anxiety on a fairly regular basis and who knows numerous other women who suffer as well, I've learned two things. First, there is a time and place for medication and there is no shame in going to a counselor to seek help. I've also learned that there is no replacement for reading the Word and praying. No amount of sleep, creative time, or vacations can refuel me like the Word. Believe me, I've tried all those things.

Why not give your control back to God? When you realize that you were never in control in the first place, it's freeing.

Practice

Wait For The Lord Be Strong & Let Your heart Take Courage

PSALM 27:14

What are you most afraid of losing? What are some passages of Scripture that give you comfort?

ADORATION

PSALM 48: THE IMPORTANCE OF THE CHURCH

Our culture today glorifies individualism and success. This has even infiltrated our churches and Christian communities. There is divisiveness among our church and communities. And often these quarrels and bickerings turn our youth away instead of drawing them in.

We also often think of the church as secondary to our faith, or monotonous. But the church is vitally important and we must remember that. Since even as Christians we all still sin, we must continue to give grace to one another when we make mistakes. We also need to look at the church and ask ourselves how we can serve the church, versus how the church can best serve us.

We have all been given gifts that are to be used to glorify God and for the benefit of the church. Oftentimes we think about the gifts that we can implement in the workplace and vocationally, but we rarely think about how we can use the gifts we have for the benefit of the church. Spiritual gifts are both special and weighty. You probably know someone who has the gift of hospitality—the person who is always having people over to their house and genuinely loves these people. While we are all called to be hospitable to others, the person with this gift has the ability to do this naturally and without a lot of effort.

No church will be perfect this side of heaven. But we still need to cherish it because it is the bride of Christ.

Practice

w w w w

W W W W

Great
IS THE
Lord
&
GREATLY
TO BE
Praised
PSALM 48:1

Do you take the church for granted? What are some practical ways that you can serve the church with your gifts?

ADORATION

PSALM 63: THE ENVY IN ALL OF US

As humans, we all struggle with envy. This is true regardless of our cultures, life-styles, and genders. Envy is in all of us. We are never satisfied. When we realize that the American dream isn't satisfying us, we go the opposite direction and hope that minimalism or having less will satisfy us. When our marriage is failing, we hope that having children will make it better. When our children don't satisfy us, we look to our career, or shopping. The list goes on and on. There are deep desires in each of us that, try as we might, we will never satisfy with anything in this world. But David has found the solution. He says, "Because your steadfast love is better than life, my lips will praise you." (verse 3) Even in the midst of his own son betraying him, David says that God's love is still better than life.

A common answer to our longings these days has been self-care. As students, we need a break from studying to do some "self-care." As exhausted mothers, we just need a break from our kids to recharge. While I do think that these things are important, self-care isn't the ultimate way that we are going to fulfill our deepest longings.

We were created by God and meant to be in a relationship with Him. So when we reject God and seek to fill that relational hole with anything in this world, it will never work. Nothing can fill that longing and emptiness except God Himself.

X X X X

X X X

i will
bless
you
as long
as i live

PSALM 63:4

Who is God in this passage? What are some ways that you envy others?

ADORATION

PSALM 144: THE GRACE THAT GOD GIVES US

As I've been studying the Psalms in preparation for this devotional, Psalm 144 stuck out to me during a period of time when I had writer's block. The first two verses of this Psalm are both powerful and personal. David begins by praising God and then listing off all of the attributes of God that personally affect him. David says that the Lord is "my steadfast love and my fortress, my stronghold and my deliverer, my shield and he in whom I take refuge." (verse 2) Growing up I often viewed God as someone who was always angry with me when I sinned, and I often felt like I needed to "get my act together" before I approached God. When I started learning more about grace, I realized that the way I had viewed God my whole life was skewed. While I sometimes still fall back into that mind frame, verses like Psalm 144:1–2 are powerful reminders for me of who the Lord truly is.

Notice that David's first description of the Lord is "steadfast love." Before he lists out any other attributes of God, he reminds himself that God is his *love*. I can easily lose this view of God when I am going through a particularly hard season of life. I question God's love for me and ask how He can love me when I'm struggling every day with a difficult baby, or a hard relationship, or infertility. Our pastor has been preaching through Exodus and gave us a powerful reminder of how God works in extremely hard circumstances. When God brought all the plagues to Egypt, He wasn't just doing it to free the Jews, He was wooing the Egyptians back to Himself by showing them who is the *true* God.

While we may not like the hard things that come with this life, we must remember that the Lord is using these difficult circumstances to make us more like Him.

Practice

Z Z Z

Y Y Y

HE IS MY
steadfast
LOVE & MY
fortress
MY
Stronghold
& MY
DELIVERER
PSALM 144:2

What are some ways that the Lord is making you more like Him through difficult circumstances?

ADORATION

PSALM 19: ALL CREATION ADORES HIS NAME

I recently planted a garden. This is something I told myself I would never do because I've always been too busy. Then the quarantine of 2020 happened and I found myself at home with two children trying to find something, anything, to fill the time. My garden is made up almost entirely of flowers, because I honestly just wanted something beautiful to brighten my home during a dark season.

Psalm 19 begins by saying, "The heavens declare the glory of God, and the sky above proclaims his handiwork." In the midst of a season of fear, chaos, hate, and uncertainty, my tiny garden in the back of my house reminds me daily of the glory of God. That He is in control. And that if He cares so much even for my tiny zinnias, how much more does He care for me and for His people?

If all of creation is made to glorify God, how much more are we as image-bearers of God made to declare the love and glory of a God?

Practice

THE
HEAVENS
declare
THE
GLORY OF GOD
& THE
SKY above
PROCLAIMS
HIS handiwork

PSALM 19:1

What particular aspect of nature reminds you of the glory of God? How can you proclaim the glory and love of God to the people around you today?

basic
ALPHABET

a b c d e f

g h i j k l

m n o p q

r s t v v w

x y z

fancy
ALPHABET

a b c d e f

g h i j k l

m n o p q

r s t v v w

x y z

Practice

Practice

Practice